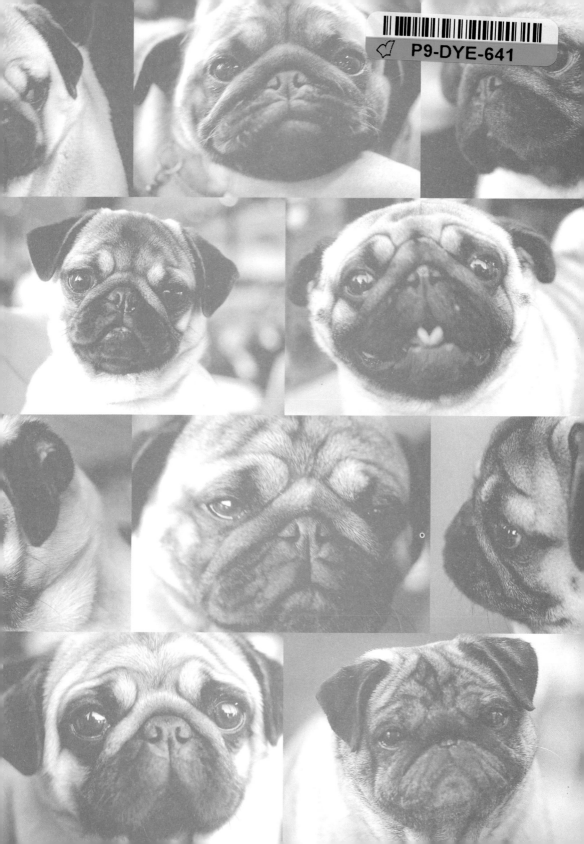

P9-DYE-641

for our mothers

Diony Stoddard Farr
Elizabeth Bowditch Bennett

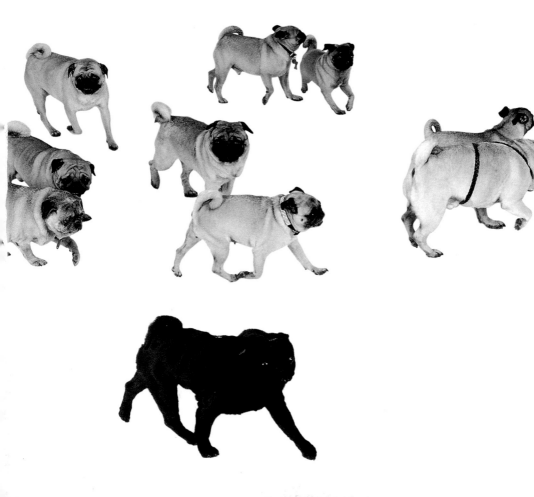

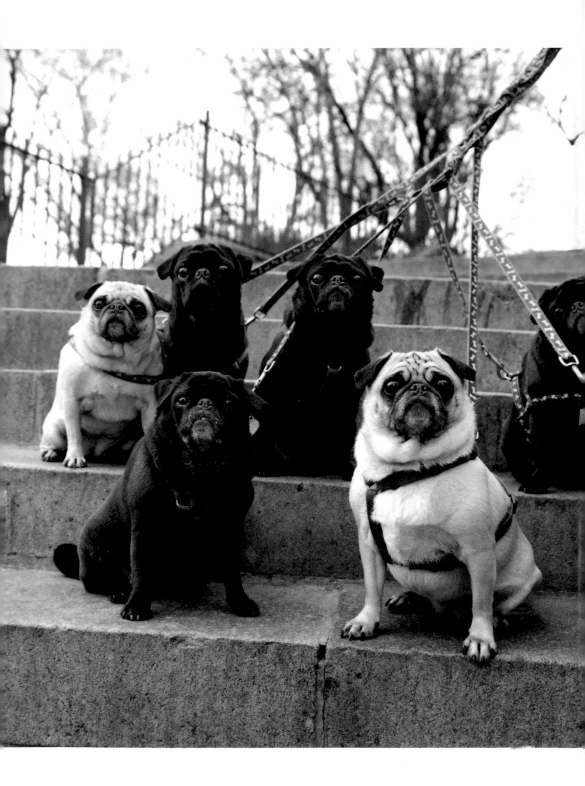

pugs
in
public

Text by
Kendall Farr

with Sarah Montague

Photographs by
George Bennett

Stewart, Tabori & Chang
NEW YORK

Published in 1999 by
Stewart, Tabori & Chang
A division of Harry N. Abrams, Inc.
115 West 18th Street
New York, NY 10011

Library of Congress Cataloging-in-Publication Data
Farr, Kendall, 1959-
 Pugs in public / Kendall Farr; photographs
by George Bennett.
 p. cm.
 ISBN 1-55670-939-0
 1. Pug. 2. Pug Pictorial works. I. Title.
 SF429.P9F37 1999
 636.76–dc21
 99-32418
 CIP

Designed by Susi Oberhelman

Printed in Hong Kong

10 9 8 7 6 5 4 3 2

contents

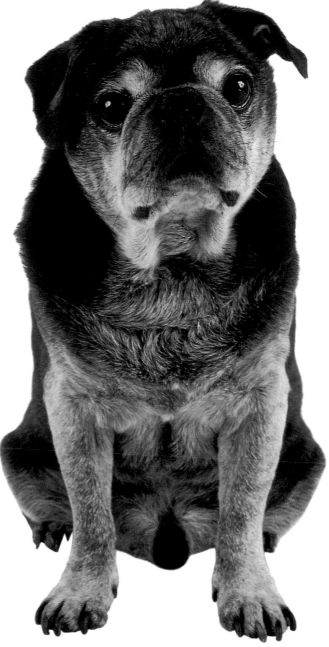

foreword

Years ago, walking home in Greenwich

Village, I passed a woman pushing her elderly pug in a baby stroller. Two younger, peppier pugs trotted patiently alongside. The pug looked positively regal sitting in her floral stroller, like a dowager queen in her carriage out to review the estate. Daisy, as she was known, looked as if she had places to go and people to see. As it turned out, she did. She may have been an old lady with a bad hip, but her owner, Cecilia Geary, whom you will meet in this book, didn't want to deprive Daisy of her daily outing. "She likes to see the world," she told me, "she has a lot of friends who look for her." I had just become another of them. I couldn't get enough of Daisy's noble, endearing face.

Our meeting had ignited a dormant childhood pug obsession. At age six, on Christmas morning, I had unwrapped *Eloise at the Plaza*, and immediately became infatuated with the story of the little girl who lives at the legendary hotel. As if her cosmopolitan lifestyle of room service and tormenting bellmen wasn't enviable enough, Eloise had Weenie, her pug. A best friend, and a partner in crime.

Eloise at the Plaza (with protopug Weenie), with contemporary allies Junley's Dinah-mite and Becky Goodman looking on. (Eloise painting by Hilary Knight.)

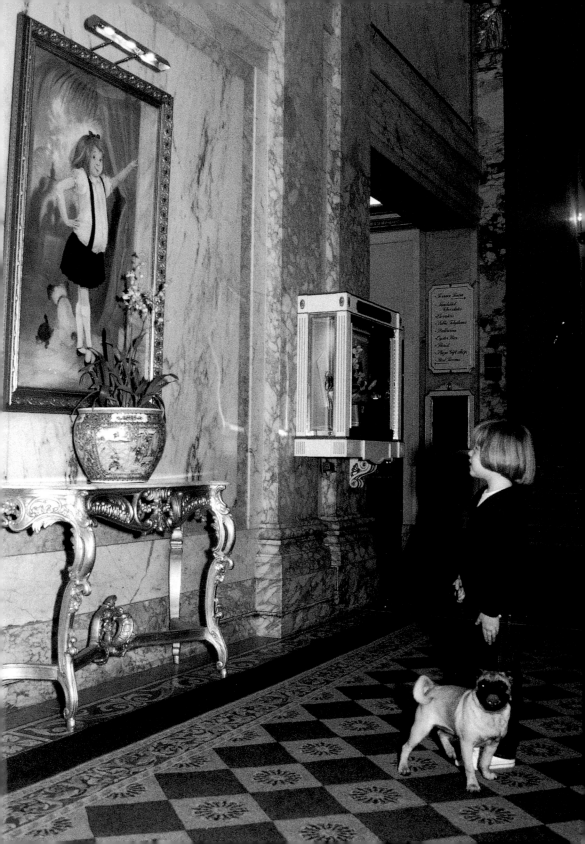

A year or so after meeting Daisy, my own beloved Annabelle arrived on the scene. A tiny force of nature, she instantly assumed control of my life. Twelve years later, I've come to understand that her remarkable personality—equal parts dignity and silliness, stubbornness and extraordinary sensitivity—belongs to all pugs.

What is it about pugs? People either understand their appeal or they miss it entirely. There isn't a pug owner alive who can't tell a story of some insensitive clod who felt compelled to tell them that their pug was

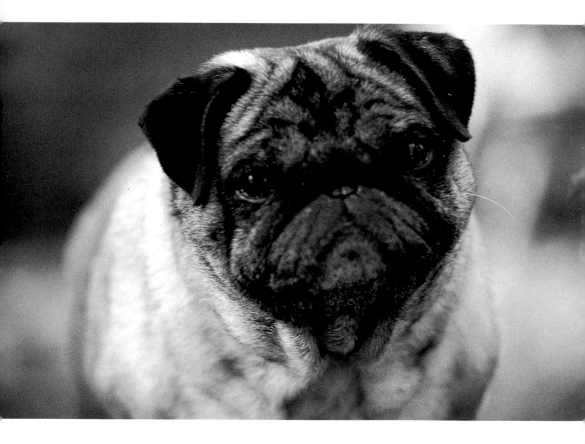

the ugliest dog they had ever seen. Let's face it, in a country filled with black labs and golden retrievers riding shotgun in SUVs, we who find pugs beautiful and distinctive are an unusual breed ourselves.

But for those of us who do love pugs, they are part of how we define ourselves. They are an emotional and aesthetic choice. In my work as a fashion stylist there have been many photo shoots where I've thought, "What's missing here? This picture could use a pug!"

Clearly, others feel the same way. As you will discover in this book, there has always been a pug nation, and pugs have insinuated themselves into the public and private lives of many people. This "nation" found itself very much on the map after the highly publicized 1998 Sotheby's auction featuring pug *objets d'art* and memorabilia belonging to the Duke and Duchess of Windsor, and now pugs are enjoying what the fashion world refers to as a "moment." Their faces have become cultural icons (not for the first time), appearing in fashion magazines, catalogs, TV commercials, and films. On the cover of this book you will see a Moschino dress inspired by the Windsors' famous lawn parties of the 1960s—only one of the many ways pug fancy has flowed life into art.

Pugs may be in the *zeitgeist*, but their appeal is timeless. This book is a love letter to Annabelle and to a breed apart.

introduction

The pug comes by its sense of privilege

naturally, and has a personality that has been formed by over three thousand years of pampering. Pugs avoided the ugly business of survival of the fittest: unlike the earliest dogs, circling the campfire looking for a way into human society, they were born into the lap of luxury. Literally. Bred to adorn the laps of Chinese emperors during the Shang dynasty (1766-1122 BC), pugs were central to court life. (One especially infatuated ruler, Emperor Lung-Tu, awarded his pug with the country's highest level of literary achievement, the Hosien grade, complete with official hat and belt!) Pugs had their own servants and were transported in custom-built carriages. In these they travelled to royal hunts (other less exalted canines walked) where they were carried out to the field to stalk their quarry and then returned to the silken cushions on which they customarily reclined. This combination of vivacity and nobility remains a hallmark of the breed.

As the world expanded, the curiosities as well as the staples of exotic regions travelled abroad to infiltrate other cultures, and the pug's popularity spread next to Tibet (where they were kept by monks, though it is hard to imagine the pug's prankish and irreverent tempera-

A display of objects from the Sotheby's Windsor auction (the Duchess appears with five companions in the photograph) at Bergdorf Goodman, September 1997. Items from the sale fetched as much as ten times their estimated price.

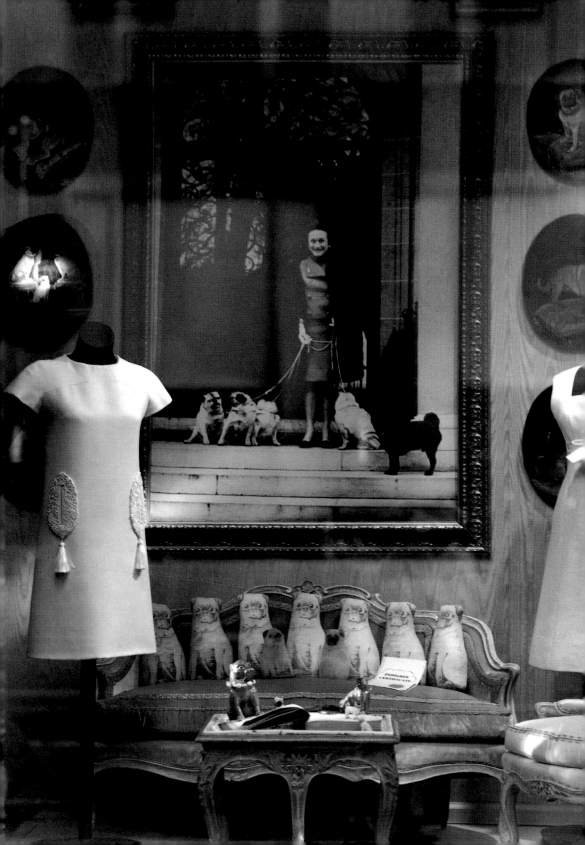

ment as an asset to the contemplative life) and Japan, and then to Europe. Long fashionable as a diplomatic gift, the breed was first imported in the late sixteenth and early seventeenth centuries by merchants and crews from the Dutch East Indies Trading Company. But pugs soon made their way back to court, becoming the darlings of the novelty-hungry Dutch upper classes and even gaining mascot status when William the Silent, the Duke of Orange, was saved from an ambush by Spanish troops by his pug Pompey. In a characteristic gesture, Pompey leapt onto his master's face to alert him to the attack, and was subsequently decorated for bravery. The pug

Meissen pugs,
Asprey & Garrard,
New York.

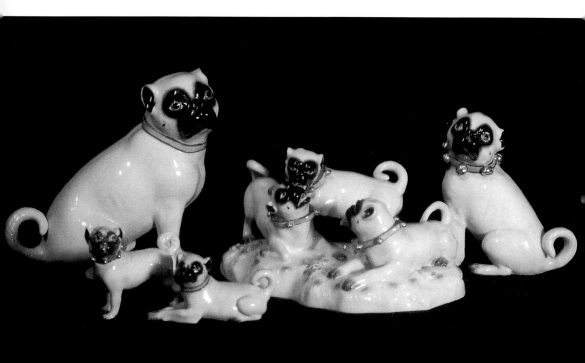

became the official dog of the House of Orange, and travelled with William III and Mary II when they left Holland to ascend the English throne in 1688, their collars threaded with orange ribbons to signify their place in the world. And it is not surprising that eighteenth-century English society, with its wits and fops and love of ornament, should have continued to embrace the pug.

This century also saw pugs' popularity on the rise in other European countries. In Spain they were painted by Goya, in Italy pugs dressed in matching jackets and pantaloons sat by the coachmen of the modishly rich, and in Germany and France pugs appear several times as colorful footnotes to history.

In Saxony, where they were known as "mopshonds," they drew the eye of the craftsmen of Meissen, who immortalized their contours in highly prized porcelain figurines. One of the town's frequent patrons was the Elector of Saxony, who was also the Grand Master of Freemasons, and when the Pope excommunicated the Masons in Germany, the Elector's order proudly declared themselves the "Mopsorder," or Order of the Pug, with the dogs as their secret symbol.

This term gave a name to the pet of one of the breed's less fortunate patrons, Marie Antoinette, who arranged to have her pug Mop sent to her from Vienna in the early days of her marriage. Perhaps because of this, pugs were well established in France by 1790, and

the French Revolution does not appear to have dimmed their star: Josephine Bonaparte's pug Fortune is supposed to have bit Napoleon on his wedding night, probably recognizing an ego that might have rivalled his own. Later—a truce presumably having been declared—Napoleon hid love letters under Fortune's collar to be carried to Josephine while she was imprisoned at Les Carmes in 1794.

In nineteenth-century England, pug fancy flourished under the patronage of that not un-pug-like monarch Queen Victoria. Her many pugs, which she bred herself, gloried in such names as Olga, Pedro, Minka, Fatima, and Venus. (A favorite, Bosco, is buried under his own memorial in Frogmore House Gardens.) Though she could be a trial to her children, Victoria was an ardent champion of animals, and was instrumental in ending the barbaric custom of cropping—and sometimes amputating—pugs' ears to make them more winsome. Her involvement with dogs in general helped to establish the Kennel Club, which was formed in England in 1873.

Victoria favored the lighter colored, fawn pugs, but another aristocrat, the globe-trotting Lady Brassey, is credited with making black pugs fashionable after several she brought back from China had successful show careers.

But the pug also thrived in more democratic cir-

cles, arriving in America sometime in the nineteenth century (the American Kennel Club recognized the breed in 1885) and soon making its way into the family home and the show ring. Some of America's most distinguished pugs hark back to the breed's earliest origins: During the siege of Peking in 1860 two pugs, subsequently named Lamb and Moss, were stolen from the Emperor's palace—evidence, perhaps, of the breed's ability to captivate even the busiest plunderer. Back in

A black pug appears in William Hogarth's *House of Cards* (1730) but they did not really gain popularity in England until the late nineteenth century, when globe-trotting Lady Brassey smuggled several out of China.

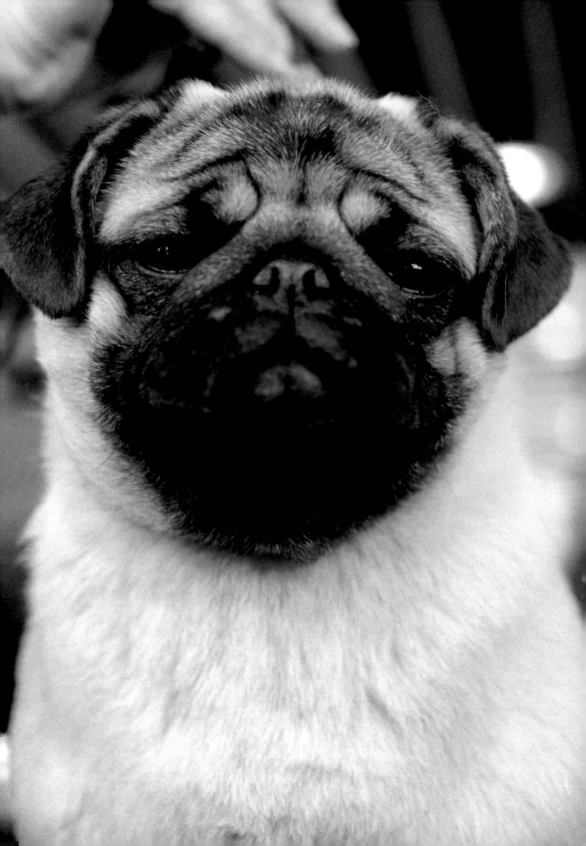

England, Lamb and Moss were mated, and their son, aptly called Click, became the foundation sire for many successful English and American lines. The breed is currently seventeenth on the American Kennel Club's list of top fifty registrations.

By Any Other Name

The name "pug," as neat and compact as the dog itself, has disputed origins. In early China the dogs were known alternatively as Lo-Chiang-Sze or Foo (ceramic foos, transmogrified into dragons, with their bulging eyes and ritually gaping mouths, are unmistakably pug-like). "Pug," the name given them in England, may have derived from another eighteenth-century pet vogue—the pet monkeys kept by fashionable nobility were known as pugs. However, two semantic explanations suggest that the name came from either the Latin *pugnus*, or fist (a reference to the dogs' clenched and folded faces) or, in a nod to the breed's mischievous nature, from the irrepressible Puck of *A Midsummer Night's Dream*.

Multum in Parvo

If we don't know what's in a name, we do know what's meant to be in a pug. *Multum in parvo*, the Latin motto that is traditionally used to sum up the pug, means "a lot in a little," in this case, a lot of dog in a small package. While pugs in eighteenth-century prints tend

Pug perfect. A deep black mask, large, solicitous eyes, soft "rosebud" ears, and the Chinese "Prince" mark etched into the wrinkles on the forehead.

to be long and lean, the current breed standard calls for a square, "cobby" body, a compact form, deep chest, and well-developed muscle. (Pugs have a tactile heft, like well-worked bread dough.)

Their heads, carried high on arched necks, should be substantial and round, the better to accentuate their crowning glory—large, dark eyes. The wrinkles on their foreheads should be distinct and deep, and were especially prized by the Chinese when they seemed to spell out the character for "Prince." Some of the breed standard, in fact, reads like a bodice-ripping romance novel, where the ideal hero or heroine possesses "rose" or "button" ears, and an expression that is "solicitous" at rest but "full of fire" when impassioned!

Pugs carry their history in their fine glossy coats, which can be apricot, fawn (or on rare occasions a combination of the two), silver, or black, and often indicate which of two early English bloodlines, the "Willoughby" or the "Morrison," a dog descends from. Good marriages obsess breeders as much as they concern socially conscious parents, and some early interbreeding left trace elements of black in the fawn, silver, and apricot lines, but this is no longer considered ideal (breeders refer to the look, disparagingly, as "smutty"). Instead, a distinct black "backtrace," like a thin stroke by a calligrapher, is considered most desirable. Also required (other than in blacks), perhaps in unconscious homage

Equal parts dignity and silliness.

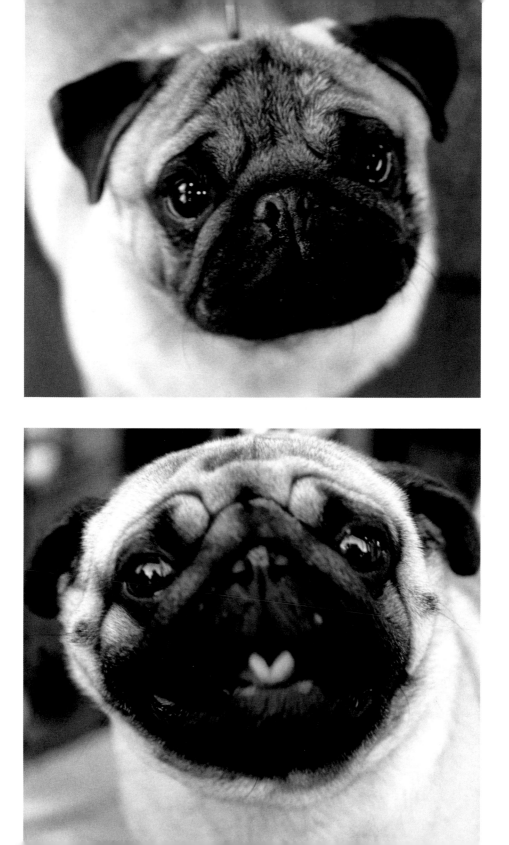

to their eighteenth-century heyday, are a dark mask and a variety of beauty marks—moles and diamonds on their cheeks and foreheads similar to the "patches" worn by Regency dandies and coquettes. And the entire package is accented by a plumed knot of a tail curling at least once, preferably twice, over the back—a reminder that pugs were designed, not merely evolved.

But *multum in parvo* has a wider application, referring not only to conformation, but to character. Noble and clownish, solemn and impetuous, one moment dreamy and the next barking in righteous indignation, a pug's mood and expression responds to every stimulus,

"Pug" may have been derived from the Latin *pugnus*; the pug's face can look a little like a clenched fist.

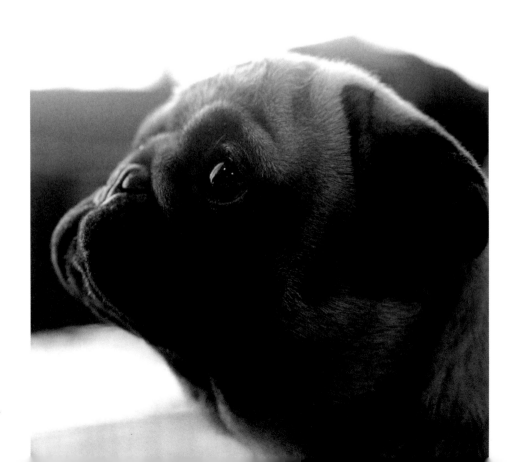

giving the impression that there are at least a dozen dogs packed into one. "The great pleasure of a dog," observed Samuel Butler, "is that you may make a fool of yourself with him and not only will he not scold you, but he will make a fool of himself too."

If pugs inherit their sweet sense of entitlement from their exalted beginnings, they share their love without reservation. (A *Dog Fancy* article from August 1998 quotes one breeder as saying, "They would hold the flashlight for the burglar.") Uniquely themselves, pugs live for their connection to us, and the distance from lap to heart is very short.

Finishing touch. The tail should curl tightly over the hip; a double curl is considered perfection.

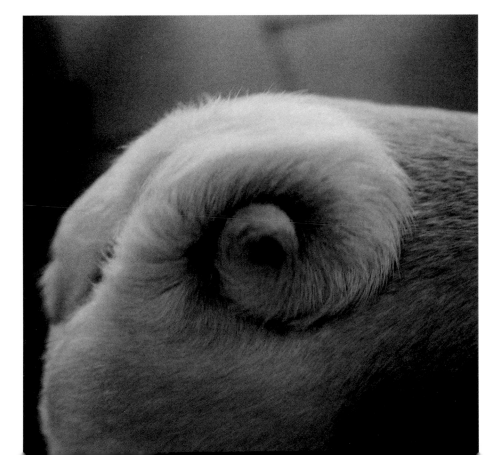

pugs
about
town

Pugs are the ultimate companion animal,

and have a way of insinuating themselves into their owners public and private lives. This is evident in some of the earliest terms used to describe them—a Sung dynasty text refers to them as "under-table" dogs, and in seventeenth-century China especially small pugs were bred as "sleeve dogs" that could be carried everywhere in the sleeves of a ceremonial robe.

The pug's presence in art and media, as both decorative and comic motif, reflects the constancy of their place in culture and daily life. Their changeable faces and plump, malleable bodies have drawn the eye of many painters and decorative artists, from the creators of dainty micromosaics and sentimental tapestries to such social satirists as the eighteenth-century painter William Hogarth, whose pug Trump is featured in many of his works (including his celebrated *Self Portrait* in the Tate Gallery in London).

Friends strolling in Washington Square Park, New York.

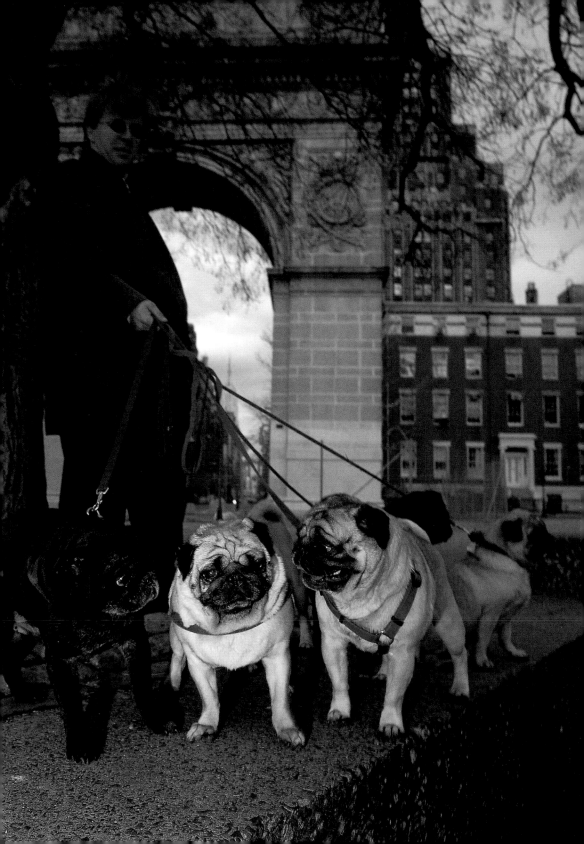

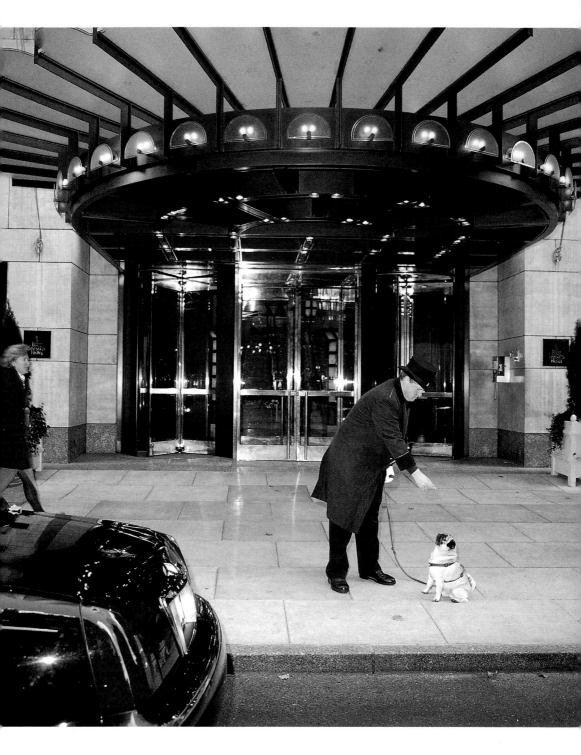

In film, pugs have been used to comic advantage in *Tom Jones* (whose author Henry Fielding based many of his images on Hogarth prints), *The Great Gatsby*, *The Great Race* ("I *hate* you!" hisses the mustache-twirling villain, Professor Fate—played by Jack Lemmon—as he is swarmed by pugs), and *Men in Black*, where the pug is a convenient disguise for an alien with attitude ("If you don't like it, you can kiss my furry butt."). The film's creators may have been inspired by the fact that many people *already* think of pugs as aliens.

The breed's most affecting appearance, of course, was in the 1989 Japanese film *Milo and Otis* (Otis is the pug), a rite-of-passage tale about a pug and a Siamese cat growing up together in the country.

One of the charms of *Milo and Otis* is that it has no people in it, but this is in fact a rare state of affairs for pugs, who crave social life, and are happy to make themselves at home anywhere. From the court to the cathedral, the studio to the shop, pugs are the perfect foils for a wide variety of professional lives, and are game for every sort of excursion from a drive in the country to a trip to the farmers' market. Pugs especially thrive in environments where they can greet their public, and whether it be an art gallery, a model agency, a pharmacy, or a café, their *metier* is making friends.

After window shopping at Dunhill and Hermès, Tuck stops for a biscuit break at the Four Seasons Hotel, New York.

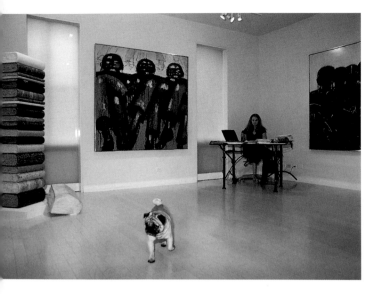

The Peter Findlay Gallery

Visitors to the prestigious Peter Findlay Gallery in New York City can view their murals and bronzes (Lester Johnson, left; Renoir, right) accompanied by Tuck, gallery guide and living work of art. Staff member Tuck is on hand daily for tours.

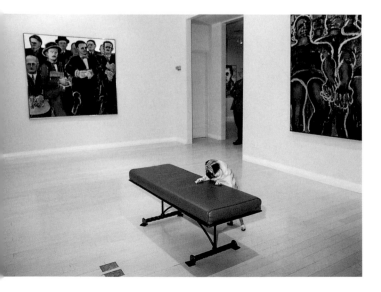

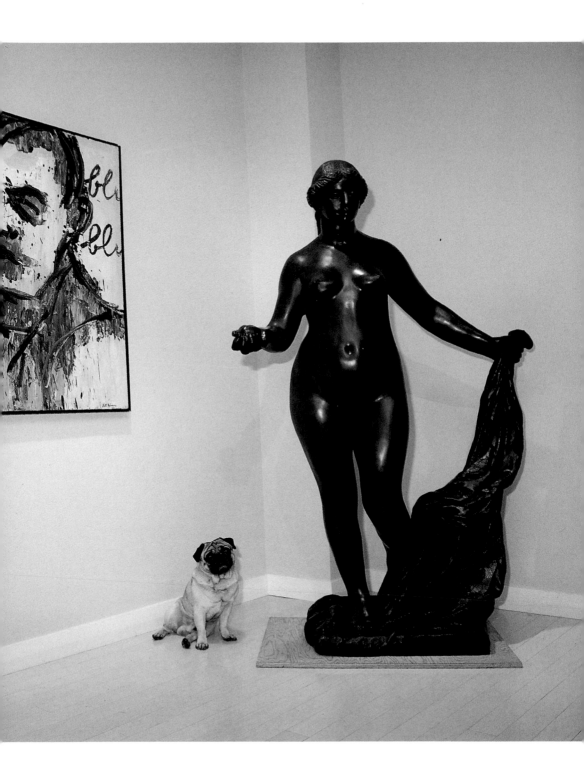

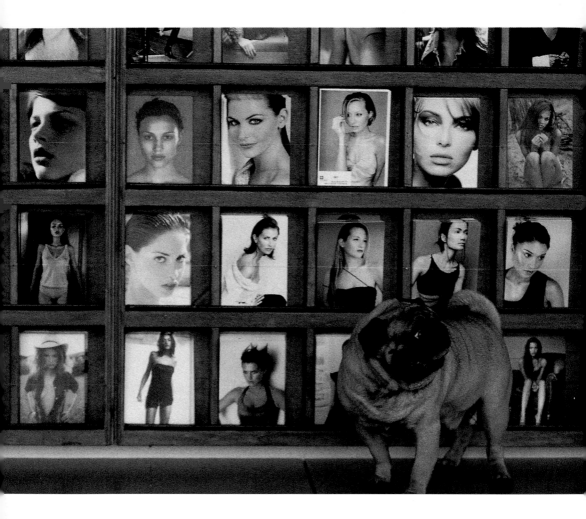

IMG Models

Pug ugly has no meaning for IMG's promotions director Stewart Ross. If beauty is in the eye of the beholder, then pug Mikey holds his own in a daily parade of cover girls (having been featured himself in *Harper's Bazaar*). Here he peruses Fatimah's (left) and Nikki's (right) newest pages. Above, Mikey demonstrates the importance of a great runway walk.

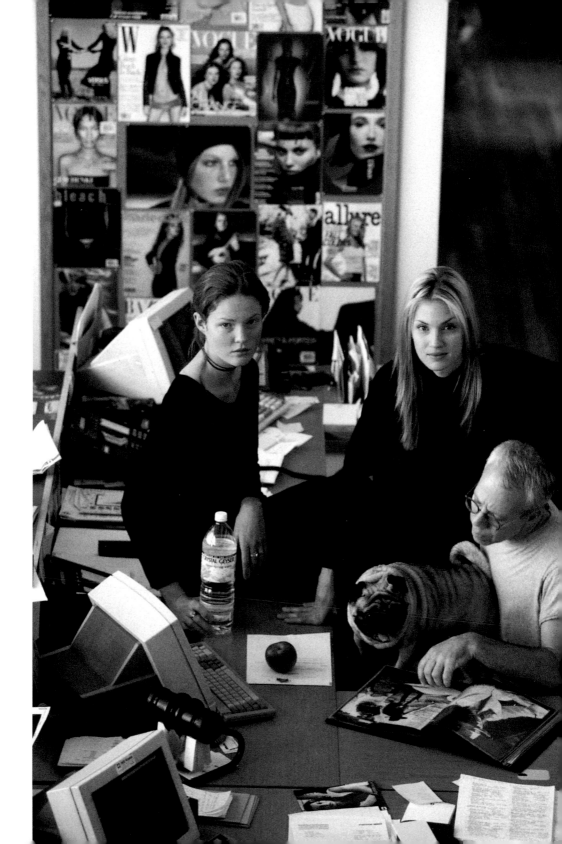

Cecilia Geary

For over thirty years Cecilia Geary has reigned as the undisputed "Pug Lady" of Greenwich Village. Her Cealyanne Pugs have produced homebred champions including Ch. Cealyanne's Dazzling Daisy (she of the stroller!). Ceil (as she is known to friends) and her pugs are a familiar and often traffic-stopping sight on the quiet streets of the Village. Her neighbors are also

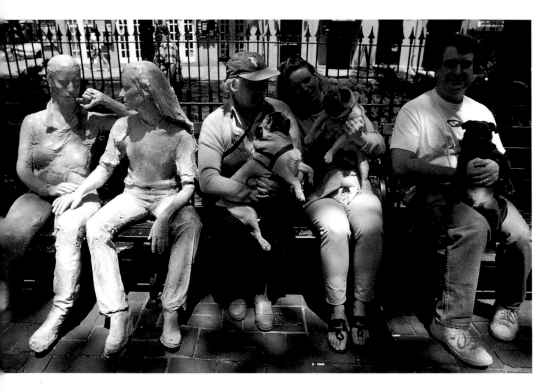

accustomed to the sight of Ceil's daily "pug constitutional" on her rooftop terrace. (A patient from nearby St. Vincent's Hospital, faced with this "vision" of pugs running and sunning themselves on the nearby roof, was convinced that he was hallucinating until his son encountered Ceil and the gang at street level and photographed them.) Grand Dame Julie has recently been joined by puppy Dinah-mite and the girls assist Ceil in her tireless work as Secretary of the Pug Dog Club of Greater New York. Above, pug friends in Sheridan Square Park, New York. From left to right: Cecilia Geary with Julie, Eloise Damone with Teddy, Joe Damone with Carrie.

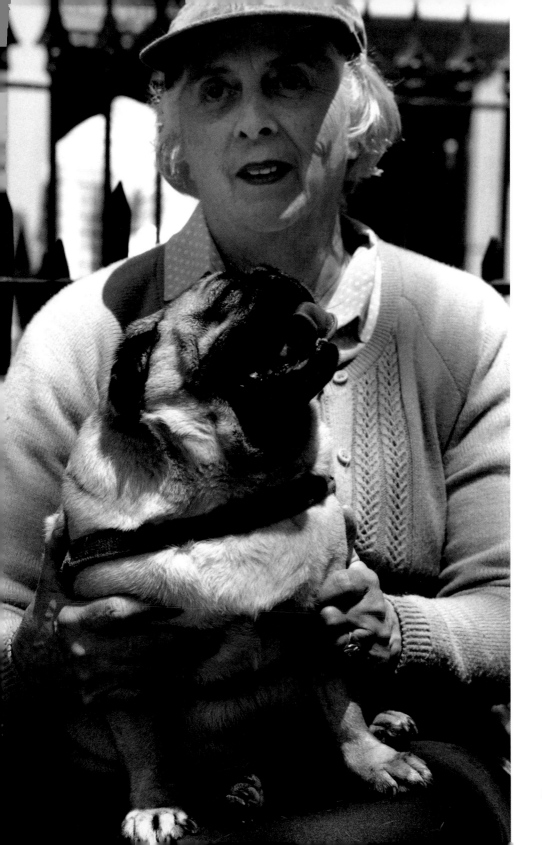

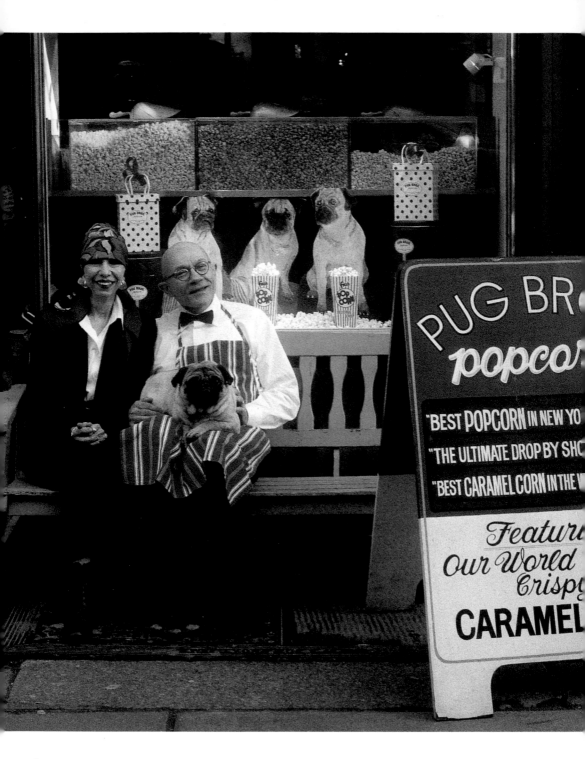

The Alps Pharmacy

Cosmopolitan pug Juliette brings a little of the Old World to the New. Three days a week she is on duty as the official greeter of the Alps Pharmacy, a gem in the heart of New York's theater district. The rest of the week finds her at home with owners Marisa and Craig Kinosian, one-time residents of Vienna whose social life was vastly expanded when neighbors spotted their visiting *mopshond* and began to invite them to pug tea parties.

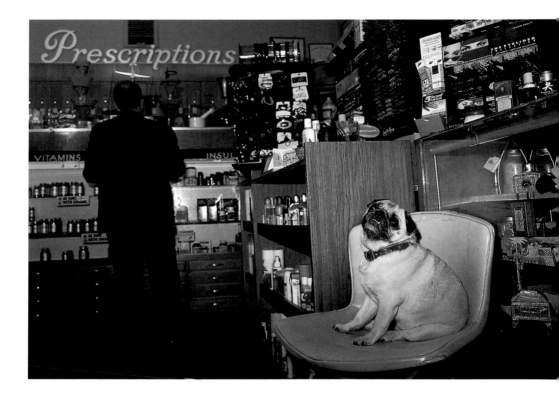

Pug Brothers Popcorn

Pugs live for food, so it is fitting that actors-turned-entrepreneurs Gary and Sonja Allen have named their successful New York novelty popcorn shop "Pug Brothers" after the pugs in their lives. If you want to have your pug and eat it too, you can order popcorn in one of four "pug" flavors: caramel—Teddy; cheese—Marco; plain with butter—Little Mo; and chocolate covered—Eddy (pictured at left). The Allens' affection takes a more serious turn in their pug rescue work of 25 years.

Shopping

"I have a dog that looks
like a cat."—Eloise

Our Saturday shopping
ritual: Coffee and the
paper at our favorite
café, and shopping at the
Union Square Green-
market, where Annabelle
chooses the produce
and makes friends. ("Isn't
it true that those dogs
were bred with cats?"
a woman in heavy New
Yawkese once asked us.
What could I say? I told
her, "Yes.")

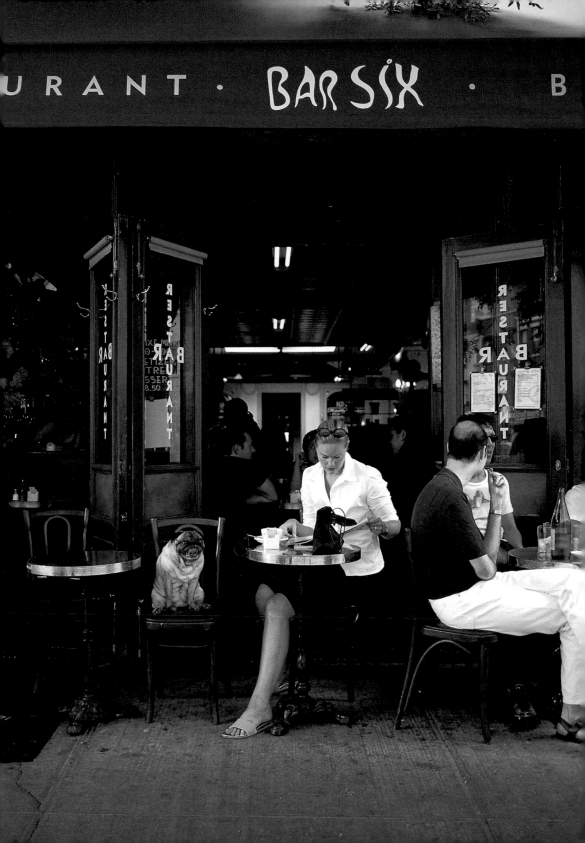

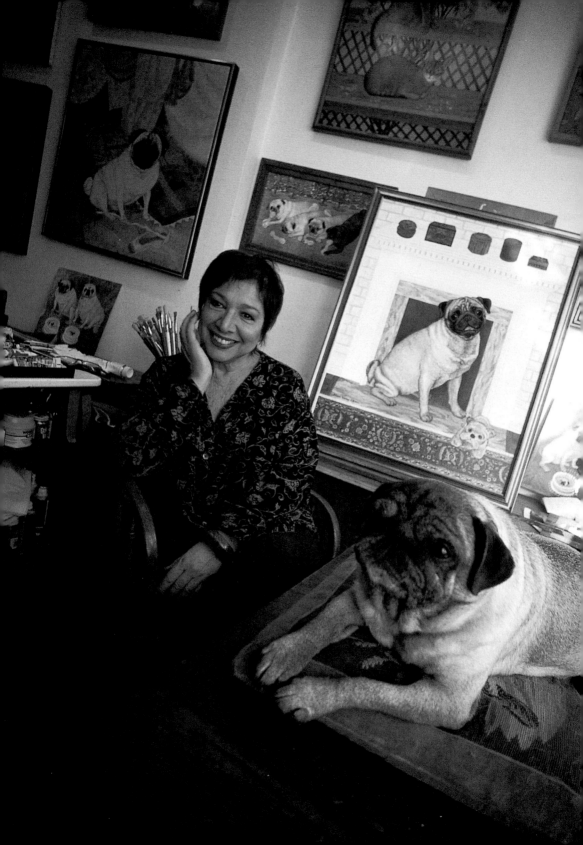

Mark Markheim Photolab owner Mark Markheim also uses pug images to spread good cheer. For years his annual holiday cards have featured pugs Alice and Trixie, who also join him enthusiastically for rides in the car.

The girls love weekend drives to the country. Trixie hunkers down on the passenger seat while Alice drapes herself over the console. Once they have arrived, the girls can often be found back in the driveway, waiting patiently alongside the passenger door, ready for their next adventure.

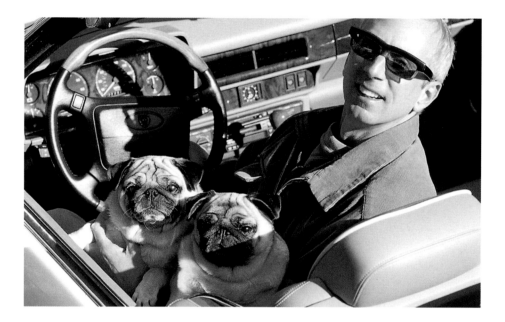

Mimi Vang Olsen Though the pug may have had its heyday as an artist's model in the nineteenth century, artist Mimi Vang Olsen is guaranteeing its immortality in the twentieth. Vang Olsen has been painting pets, posed against eye-catching folkloric tableaux, at her Greenwich Village gallery since 1983. She is especially drawn to pugs because, "They are like an odd still life—it's their misproportion: bullnecks, big eyes, legs that seem small in proportion to their chests—that makes them so interesting to paint. Their faces are incredibly expressive—they appear knowing, soulful." The artist has put her captivating images to good work, donating a series of them to the Humane Society for use on notecards. Here she visits with friend and subject, Boogie, whose portrait (center) Vang Olsen painted when she was a pug ingenue.

Café Gitane

Unfortunately for pug-besotted owners, bureaucrats are unable to perceive the subtle distinction between pugs and mere dogs. When Café Gitane opened in 1994, owner Luc Levy shared his management responsibilities—and a vinyl sofa—with pug Pee Wee (the de facto maitre d') and bulldog Tyson until the New York City Board of Health issued a humorless violation stating, "observed pug and bulldog eating croissants."

Asprey & Garrard

"We'll take two!" Charmaine Burden shops for the perfect pet carriers for brother and sister Pepe and Shirley. This luxe red crocodile ensemble, outfitted with sterling dog bowl and cashmere blanket, is $19,000 at Asprey & Garrard, New York City.

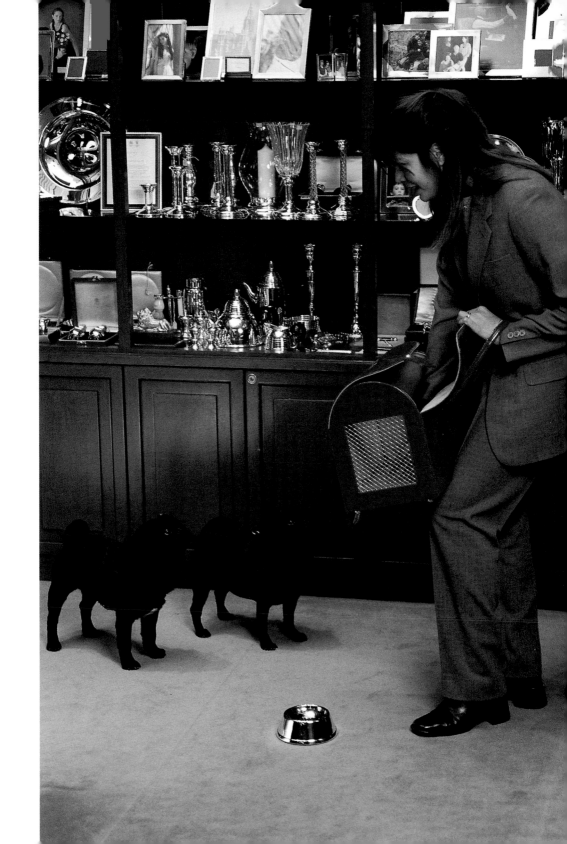

pug people

The pug is a breed apart, and so is the pug

owner. Pug people share a kind of outsider eccentricity; a gleefully subversive aesthetic that finds inspiring a face contrary to mainstream notions of beauty, and a temperament that is by turns imperious and hilarious.

Pug people have frequently been the center of attention themselves—the breed attracts the eccentric, the unconventional, the flamboyant. Pug owners are not interested in dogs who are servants, or accessories, or who seem destined for the covers of L.L. Bean catalogs, but in what Edith Wharton called "a heartbeat at my feet"—a loving friend, and a savvy co-conspirator. Their owners have been emperors and entrepreneurs, artists and actors, columnists and socialites, playwrights and designers—people with a sense of style, both within and without. This pug elite has included, among many others, Voltaire, William Hogarth, George Elliot, James

A distinctive portrait of Brigid Berlin's pugs Fame and Fortune by Alan Hirsch hangs in her living room. The artist painted from life, and inspired the pugs' plaintive expressions by balancing a slice of pizza on his head.

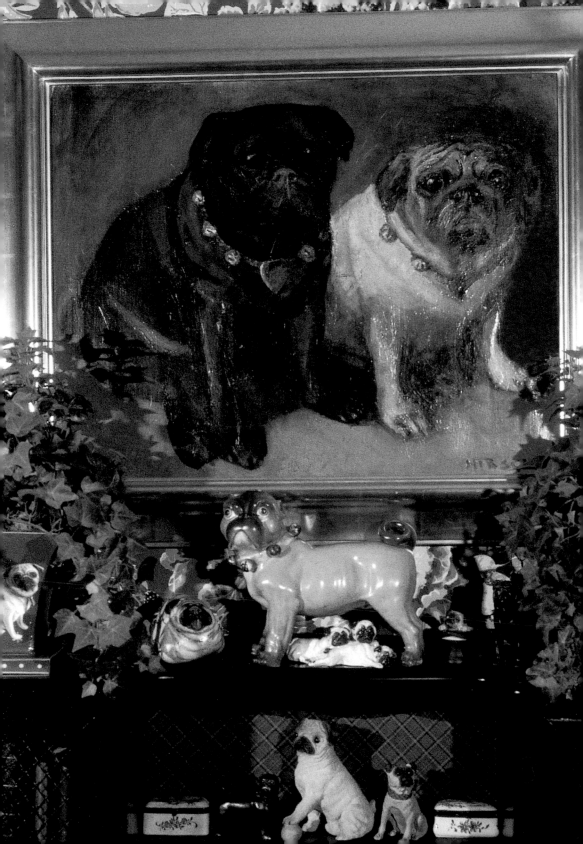

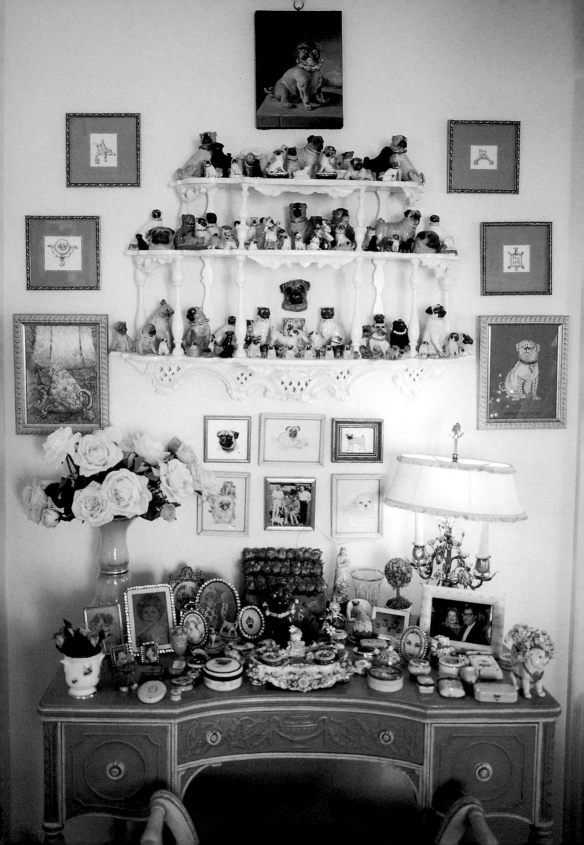

Thurber, Sylvia Sidney, *Eloise* creator Kay Thompson, Ann Margaret, Woody Harrelson, Norman Mailer, John Guare, and TCI chairman John Malone, who travels regularly with seven.

True to their birthright, pugs have an enormous appetite for contact, social life, and in-between meal snacks (as one pet food store owner put it bluntly, "step on their toes, and their mouths open"). They inspire extremes of adoration and pampering, and their owners frequently amass sizeable collections of pug paraphernalia—apparel, memorabilia, and *objets d'art*—in homage to the breed.

In the twentieth century, the quintessential pug people were the Duke and Duchess of Windsor, who owned 11 over the course of their legendary 35-year marriage.

The dogs—Rufus, Impy, Dizzy (for Disraeli), Davy Crockett, Gen Sengh, Winston, Trooper and others—provided a ready-made family and eager entourage for this childless and sometimes alienated couple, travelling everywhere with the Duke and Duchess and inhabiting a miniature version of the glittering world their owners had sacrificed for love. The pugs' routine included chef-prepared meals eaten from silver bowls, supplemented by snacks of freshly baked biscuits, and luxuriant grooming, including daily brushings and a drop or two of Miss Dior, the Duchess' signature fragrance, to keep them looking—and smelling—their best.

Brigid Berlin's pug shrine.

Caught in the Windsors' social whirl, the pugs posed for numerous photographs, sat for portraits, and appeared in the show ring. Renowned for his exquisite tailoring (he is credited with the invention of the dinner jacket) the Duke clearly set similar standards for canine fashions—the pugs had individually engraved collars of silver or Morocco leather, and small, handmade woolen travelling coats.

A tantalizing glimpse of this pug-centric life was offered during the mammoth auction of the contents of the Windsors' Bois de Boulogne house conducted by Sotheby's in February 1998. Among some 40,000 items put up for sale, pug imagery abounded, not only in photographs, sketches, and portraits, but in dozens of domestic and decorative items: embroidered bed linens with the word "Pugs" emblazoned above a coronet, Porthault towels with appliqué pugs, miniatures, scent bottles, pipes and paper knives, and a luminous array of Meissen and Derby figurines.

The Sotheby's auction drew record crowds of pug *cognoscenti* (one or two accompanied by pugs), some of whom paid record prices for a piece of canine history. And it is this same combination of high style and utter devotion that distinguishes pug owners in general: all the people in this chapter have a piece of the Windsor legacy, whether or not it was obtained from the auction block.

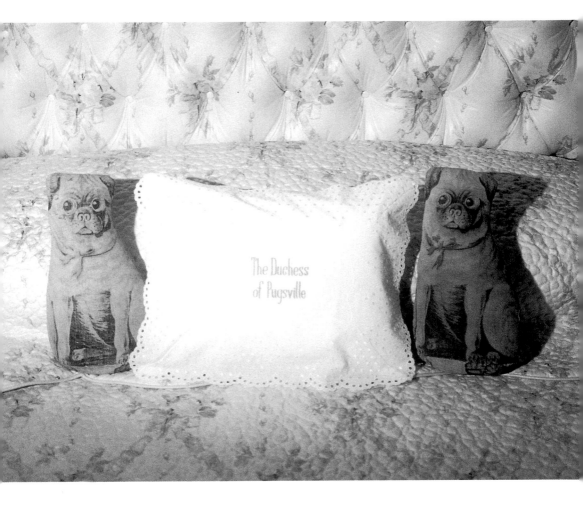

The Duchess
of Pugsville

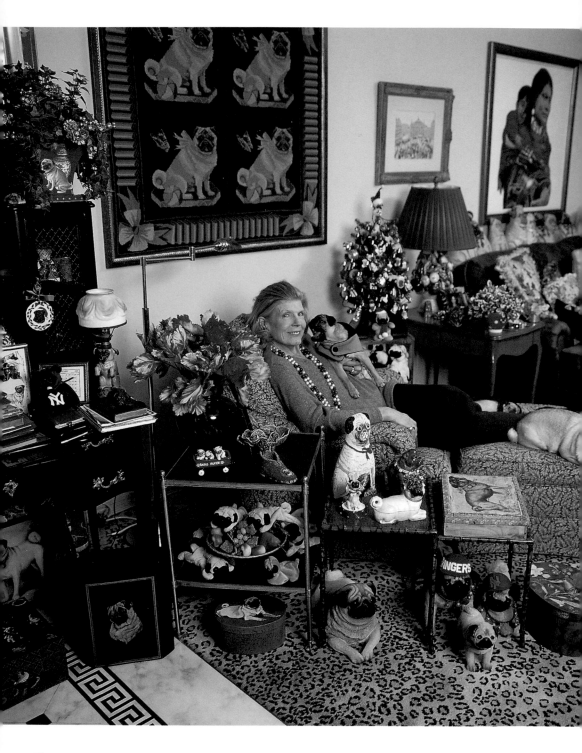

Brigid Berlin

In the case of Brigid Berlin, self-proclaimed "Queen of Pugs," the connection is a direct one, since the Windsors were friends of her parents (her father Richard was a formidable executive with Hearst magazines). In honor of this family link, Berlin's own first pug, who came from actress Sylvia Sidney, was called Wally (for Wallis).

From a childhood in high society Berlin went on to preside over Andy Warhol's Underground, working with him at The Factory as friend and muse for 25 years. Her pugs Fame (a gift from Warhol, who undoubtedly appreciated their Pop Art potential) and Fortune were fixtures of those years, and were wheeled to work in an English pram in hot weather, an image rivalling any Warholian statement in eye-catching oddness. The pugs were immortalized in oil by Alan Hirsch.

Berlin's current pug pair, Honey and Happy (our cover models), share her remarkable East Side apartment, a crazy-quilt shrine to the breed clustered with pug icons of every ilk from Hallmark to Meissen (including one sumptuous blue porcelain pug from the Windsor collection). Figurines and pictures crowd the shelves and walls, découpage pug collages adorn the surfaces of keepsake boxes, cachepots, umbrella stands, and wastepaper baskets, and the furniture is filled to overflowing with bright needlepoint pug pillows designed by Berlin. In this pug-saturated space, there doesn't seem to be any room for humans: "People mess the place up," Berlin observes unrepentantly.

The *pièce de résistance* is a miniature Christmas tree resplendent with a lifetime's collection of pug ornaments. In this delirium, one chaste, white pillow is embroidered, "The Duchess of Pugsville," a title deserved by this New York aristocrat.

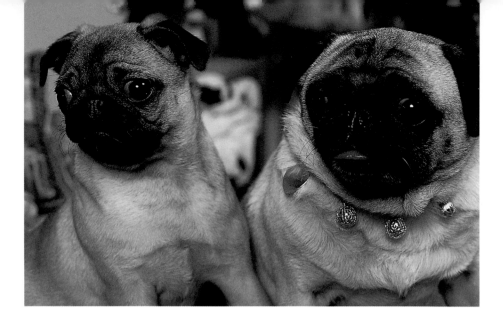

Happy and Honey, the current ladies of
Berlin's pug manor. The girls have an extensive wardrobe,
including monogrammed sweaters, chesterfield coats, and
traditional filigree ball collars from Goyard in Paris, which
has catered to discriminating pug owners for over a century.
Below, Happy with faux close friends. Right, "Where to,
lady?" Taxi driver Bobby Lowich takes Honey, Happy, and
Berlin on a shopping excursion.

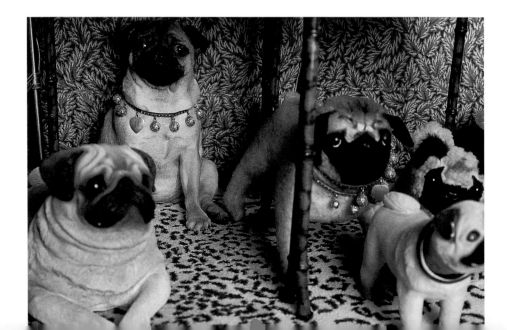

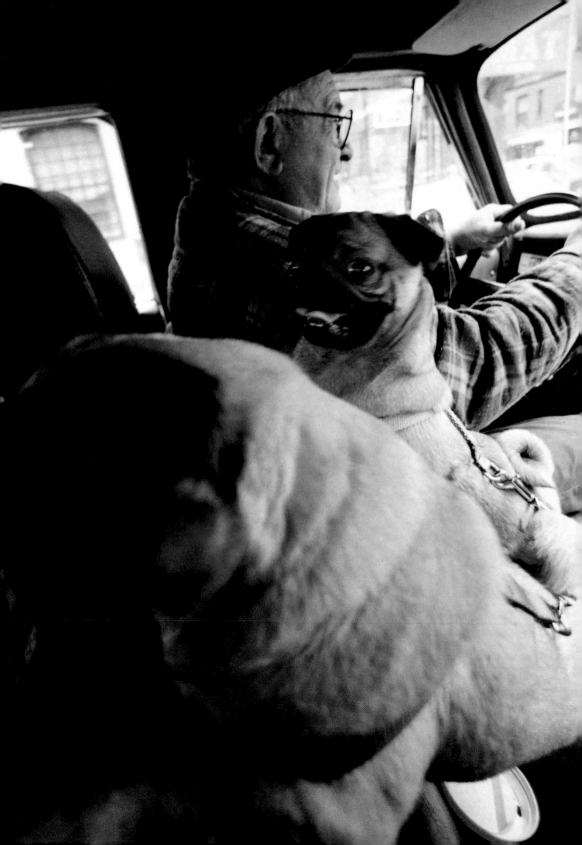

Victoria Roberts

Cartoonist Victoria Roberts, whose deceptively simple drawings hint at a sly and penetrating humor, is especially famous among pug owners for one cartoon published in *The New Yorker*. It featured a bemused couple in a

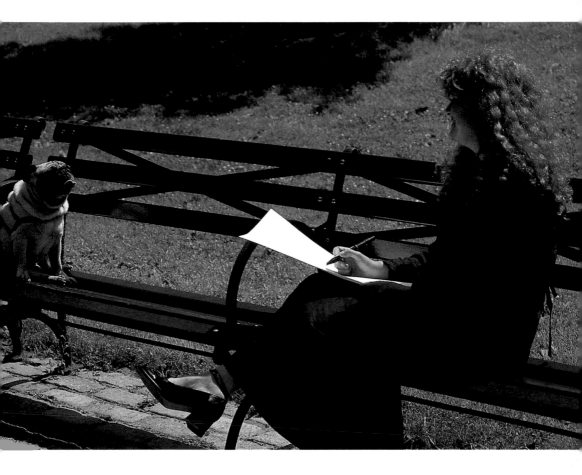

large four-poster bed, with two goofy, lop-eared pugs crowding the bed between them. It is captioned, "Lie down with pugs, wake up with pugs," which might serve as the slogan for pug captives everywhere. Roberts' pug, Pogo, is the model for many of her drawings.

Rt. Reverend Richard Grein

The childhood discovery that "Dog" is "God" spelled backwards comes as no surprise
to the Right Reverend Richard Grein, Bishop of New York, who presided over the
majestic Cathedral of St. John the Divine and is on speaking terms with both. The
Cathedral holds a "Blessing of the Animals" ceremony each October to commemorate
the birth of St. Francis of Assisi. Grein's own quarters are blessed by his pug Bruno,
whose black coat provides the ideal accent for ecclesiastical crimson.

Above, dancers from the Cathedral of St. John the Divine's "Blessing of the
Animals" ceremony and a happy blessee.

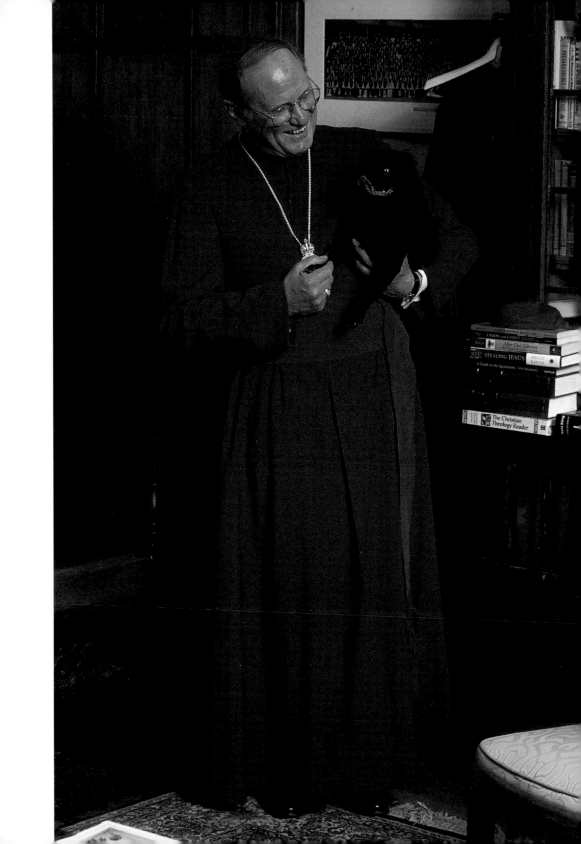

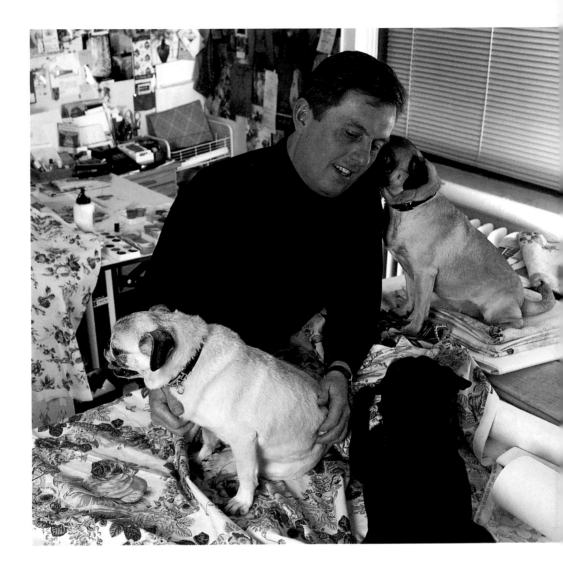

Stephen Elrod

The Creative Director of Lee Jofa Fabrics in New York
City with his trio Nina, Pita, and Mona. The girls are the
creative spark for a custom, pug-and-flower embellished
chintz, perhaps best described as "Flora and Fawns."

Marv Albert

Sportscaster Marv Albert was introduced to pugs by his wife Heather Faulkiner, and the couple now share their spacious penthouse with a winning team of fawns. Lulu (right) is known as "Energy" since she spends her days darting around the house. Ruby (left), known as "Strategy," moves as little as possible (except at mealtimes). Says Albert, "Ruby's not a practice player. She's a gamer." Pug love also runs in the family: Marv's brother Steve, also a sportscaster, caught the bug. Here he demonstrates the bravery of a man learning to navigate New York streets with a pug puppy—six-month-old Farfel.

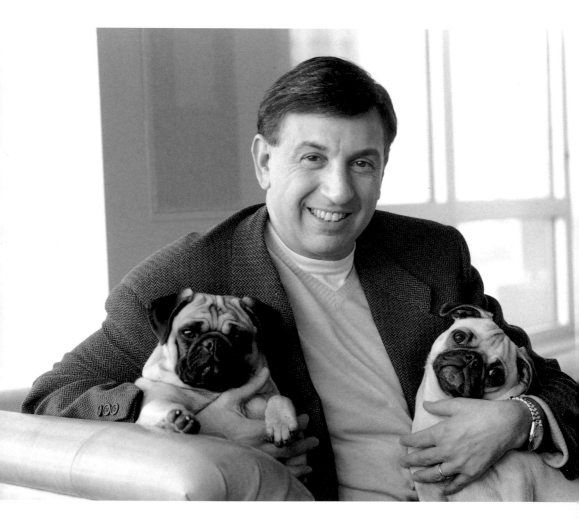

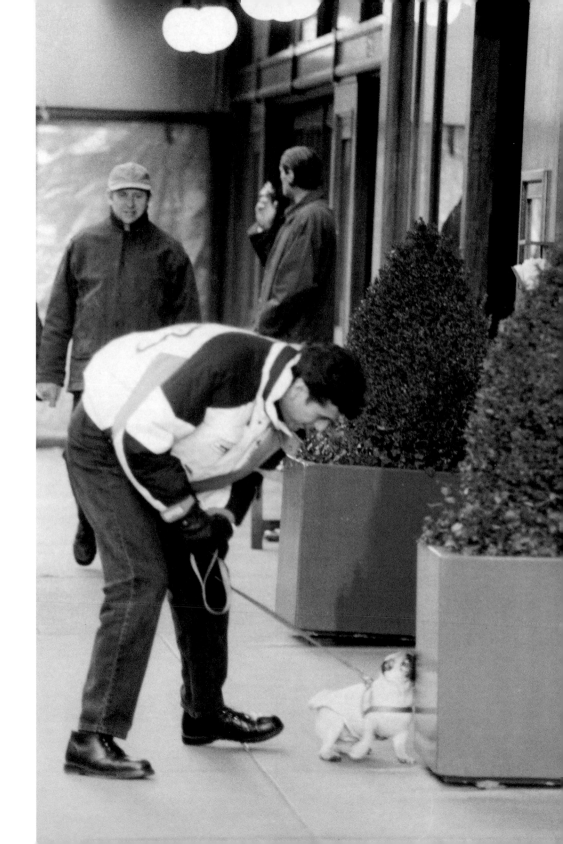

Kate Paley

Like Brigid Berlin, artist
Kate Paley, daughter of CBS
chairman William Paley
and style icon Babe Paley,
began her relationship with
pugs through an English
connection. The notorious
game show, "The $64,000
Question," later to bring
scandal to the exclusive Van
Doren family, seems to have
had a peculiar attraction
for the glamorous and intel-
lectually gifted. In this
instance the contestant was
Winston Churchill's "bril-
liant but rascally," son
Randolph. As Paley tells it,
"...Randolph, who was a
great friend of Dad's...had
gotten all the way to the last
question, the $64,000 one,
and he lost, he couldn't
think of the answer, which
was 'Captain Boycott.' So he
gave us a pug dog which
immediately became mine,
my first beloved pug—
Captain Boycott. At the
same time, in England, he
had a pug he designated
Captain Boycott. Ever since
then, there have been
other dogs, but the pug
remains *the* dog for me."

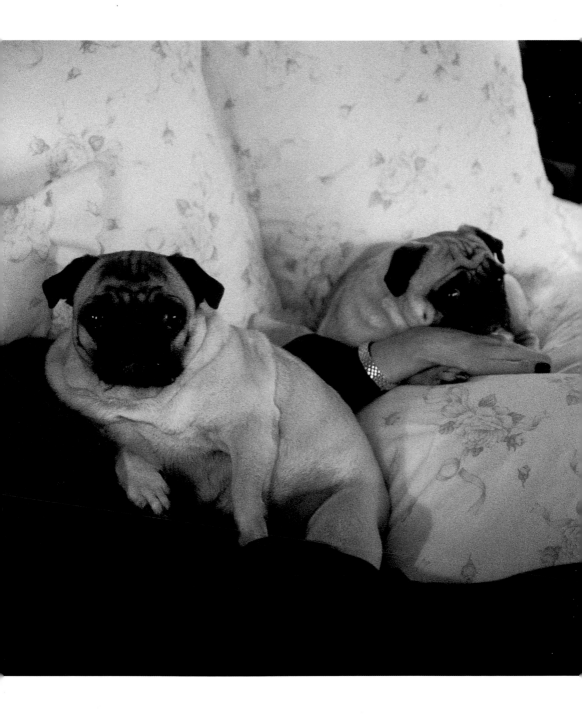

Naomi Katayama

Present-day Meissen pug figurines can be obtained at the venerable London-based emporium Asprey & Garrard, and perhaps this influenced saleswoman Naomi Katayama in her choice of breed. As with all collectibles, one is never enough, and Naomi has created her own small dynasty of blacks. Here she walks mother Sarah and father Valentine and their five offspring: Gigi, Loulou, Valentina, Anastasia, and Talo.

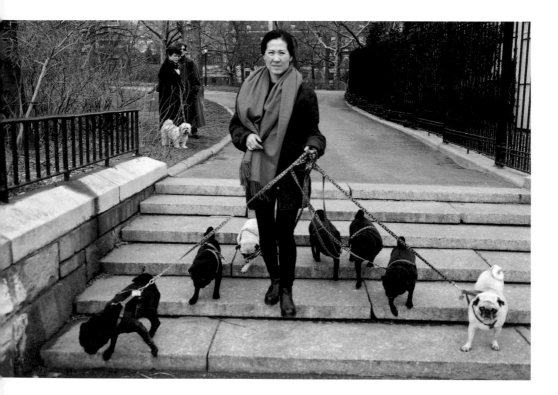

Victoria Newhouse

Architectural historian Victoria Newhouse regularly attends a pug *soiree* at the home of friend Alexandra Penney (champagne and caviar for humans, Evian and biscuits for dogs). Newhouse, author of *Towards a New Museum*, admires the playful and elegant in architectural design, so it is no surprise that she is drawn to pugs. Also quite at ease with potentates (she is the wife of media mogul S.I. Newhouse) her beloved first pug, Nero (captured in the portrait above by Neil Winogur) has been succeeded by two-year-old Cicero.

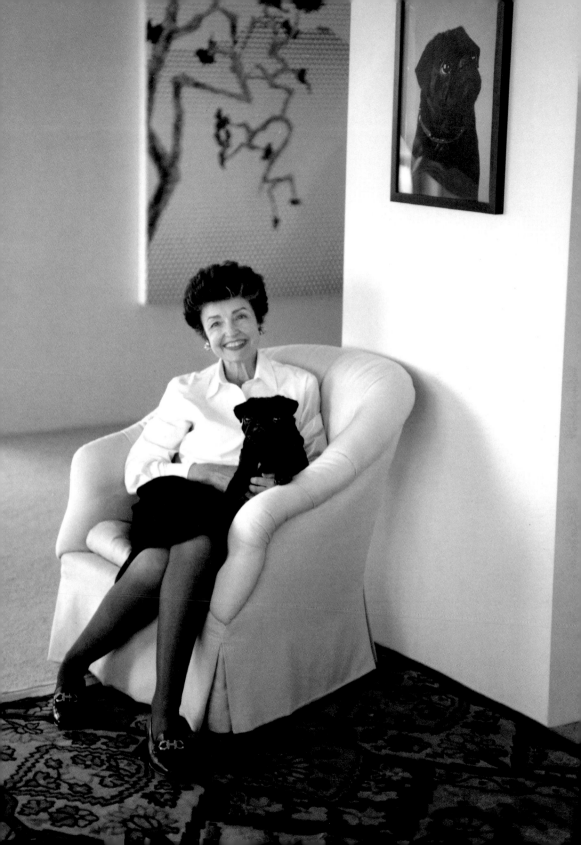

the public
pug

" 'Curiouser and curiouser,' cried Alice,"

a cry that perfectly encapsulates the topsy-turvy world of the pug fête.

It is in public rites that the Pug Nation celebrates its breed, for it is in public that pugs come most completely into their own. In show rings the distinction of pug perfect is hotly contested, but that is only the beginning. Pugs inspire a sense of occasion, and all across the country fun matches, picnics, and elegant teas bring fanciers and their enthusiastic companions together for distinguished fun.

A handler awaits
her turn in the ring.

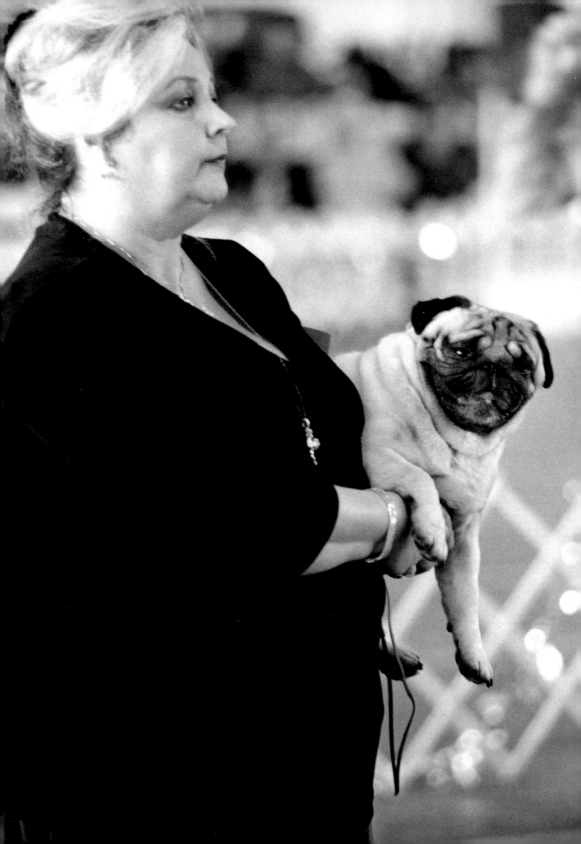

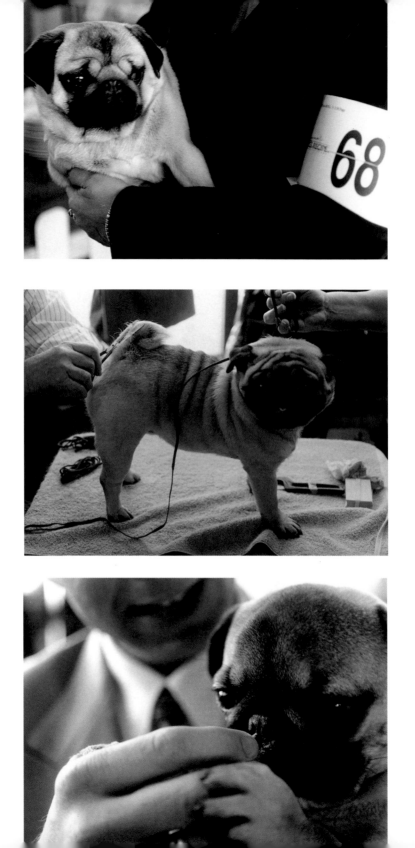

Empire Specialty Show

"Pear-shaped," "deep-brisket," "flathead," (desirable); "cow-hocked," "slab-sided," "smutty," (undesirable). Like Gulliver among the Lilliputians, the newcomer to the show ring is greeted by a bewildering vocabulary and the arcane rites of the ring. At the annual Empire Specialty Show in New York City and similar competitions all across the country, top pugs vie for coveted "Best of Breed" awards that will eventually take a lucky few to the season's zenith, the Westminster Kennel Club Dog Show at Madison Square Garden. At ringside, the event may seem like a beauty pageant or fashion show, with the spectators dishing the participants' hair color, weight, and walk. But the shows offer more than Lilliputian glory: they help to guarantee the continuity of quality animals for generations to come.

Competition aside, more than 200 pugs in one place is a gorgeous, zany spectacle, like a major runway show, dazzling the eyes of every pug lover.

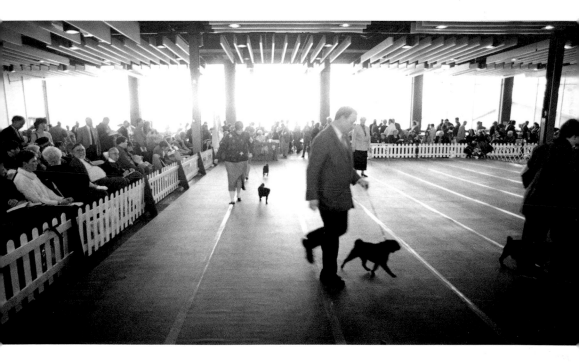

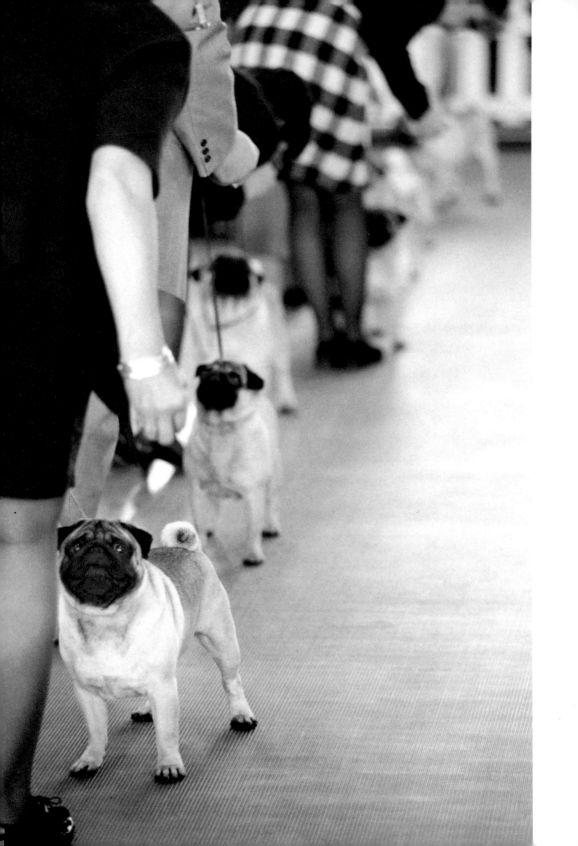

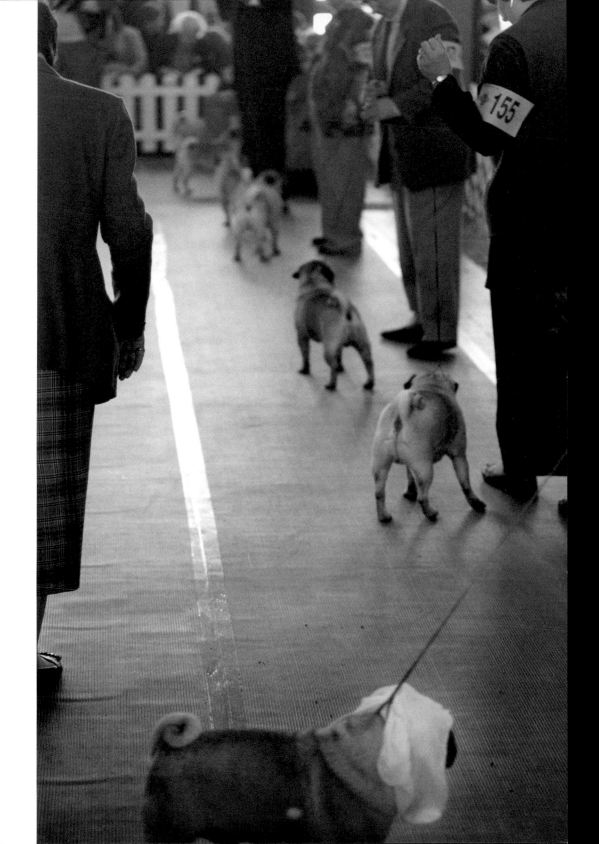

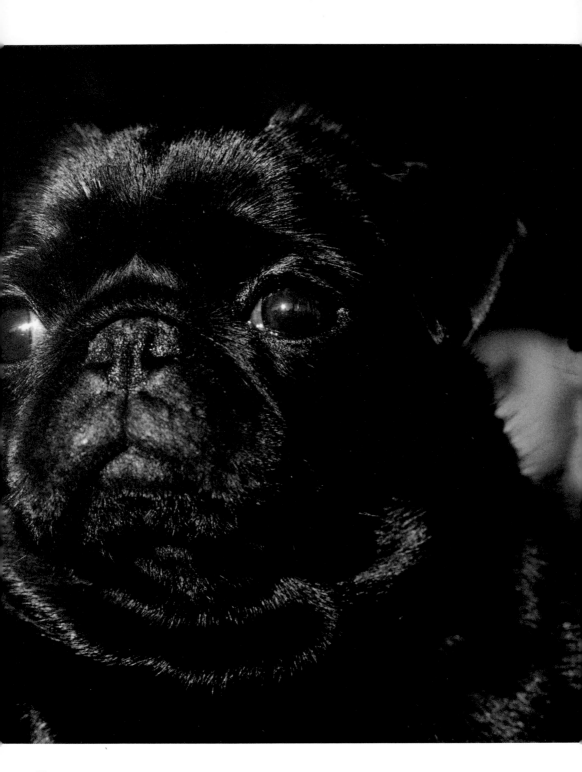

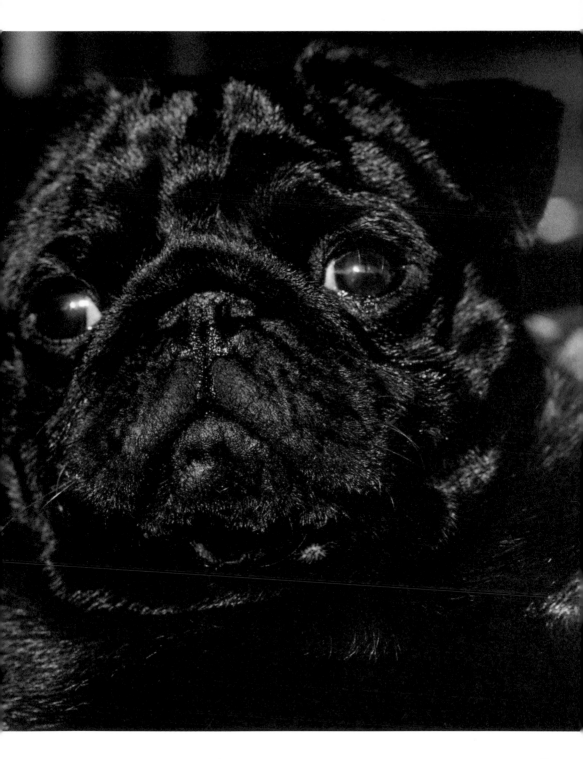

Fun Match

The Alice Austen House Museum
and Garden (right), on Staten
Island, is the site of an annual
"Fun Match" held by the Pug Dog
Club of Greater New York. Austen,
a trailblazing nineteenth-century
photojournalist, was also a pug
lover, and at this charming estate,
out of the glare of the professional
show circuit, amateur owners can
learn about grooming, handling,
and breed conformation, enter
mock breed classes, and garner
good citizenship awards for their
pugs (even beloved pugs who fall
way short of the breed standard
can excel in canine good manners).
The day also offers a leisurely
picnic lunch with pug compatriots,
and a chance to admire this year's
crop of doe-eyed puppies.

But the highlight of the Fun
Match is the costume competition.
It may seem like gilding the lily to
costume pugs, whose wry faces and
animated bodies already make
them seem uncannily human, but
a sense of humor is one of the
things that links the dogs and their
owners, and opportunities like this
prove irresistible. (Many who enjoy
the Fun Match outing also meet
weekly in New York's Central Park
in an area unofficially christened
"Pug Hill"; this pug summit has
received national news attention.)

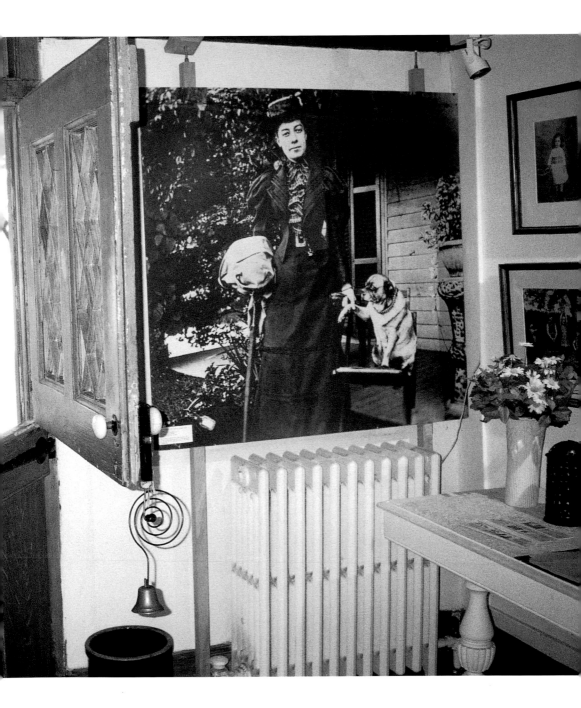

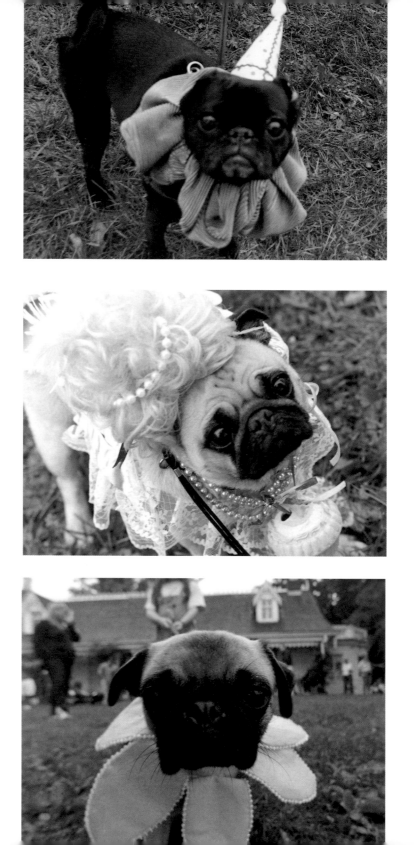

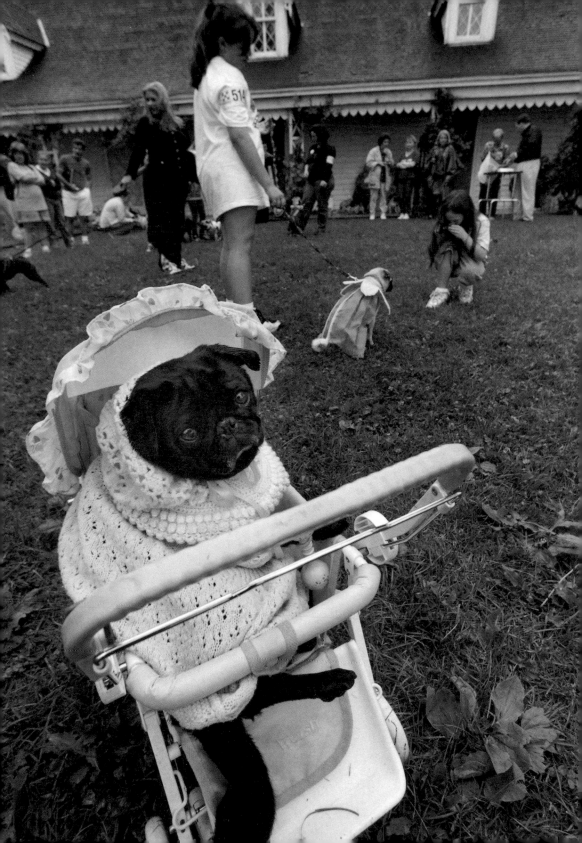

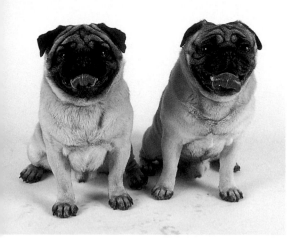

Tea Party

The tradition of pug tea parties is thought to have started during Queen Victoria's reign, and has continued everywhere that pug fanciers have had the impulse to combine the chic and the absurd (one woman featured in this book hosted her first pug tea at age five!)

The most splendid tea in recent memory launched Sotheby's Windsor sale. The "Passion for Pugs" party was held on February 14, 1998, and included well over 100 well-dressed pugs (many were national champions, since the auction was held the same week as the Westminster Kennel Club Dog Show) with equally soigné human companions, who overflowed the foyer and café space at Sotheby's New York headquarters. After a sumptuous tea of "petit paws," the pugs viewed the collection of Windsor pug memorabilia and dreamed of fame.

To honor the tradition and spirit of such events once held in gracious drawing rooms, or on manicured lawns, we staged a combined tea party and photo shoot at New York City's Drive-In studio. Here, 30 pug friends and fanciers helped us to redefine the term "party animal."

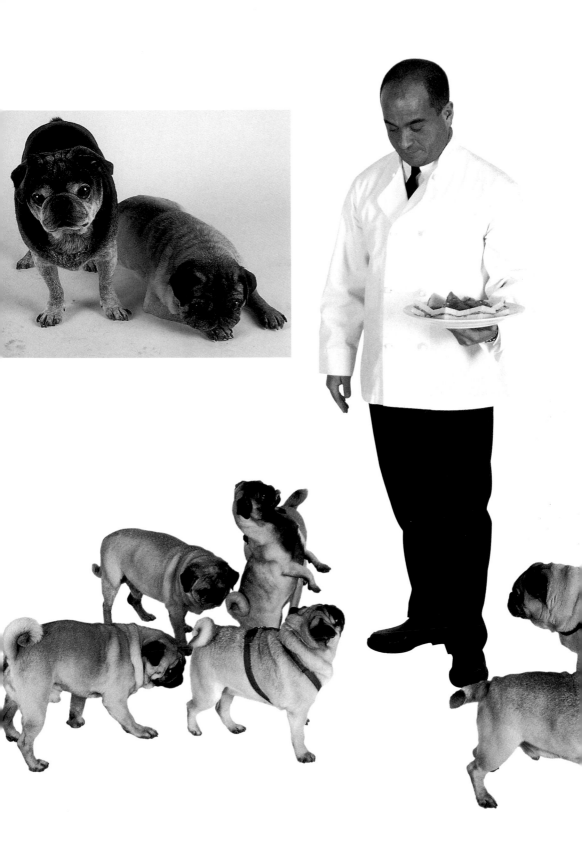

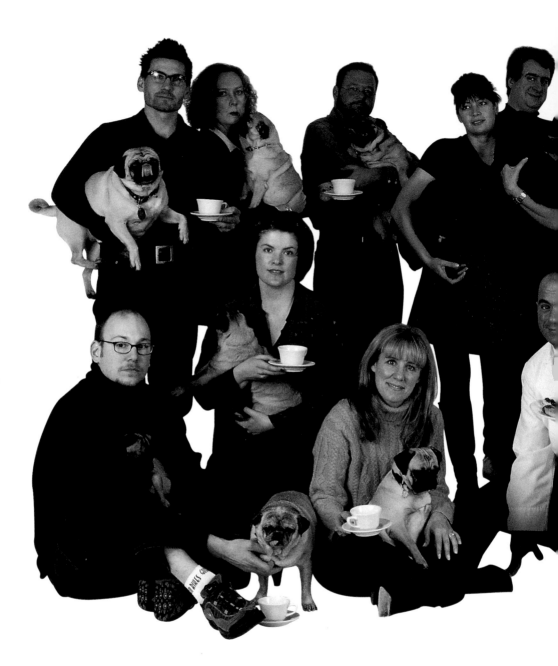

A great day in Pugsville. Top row, left to right: Marcus Accord and Sam; Cathy Frost and Carmelita; Bill Farmer and Mikey; Charmaine Burden with Pepe and Shirley; Joe and Eloise Damone with Carrie and Teddy; Newell Turner with Betty and Jack; June Francis and Teddy 2; Marv Albert and Lulu; Steve Albert and Farfel.

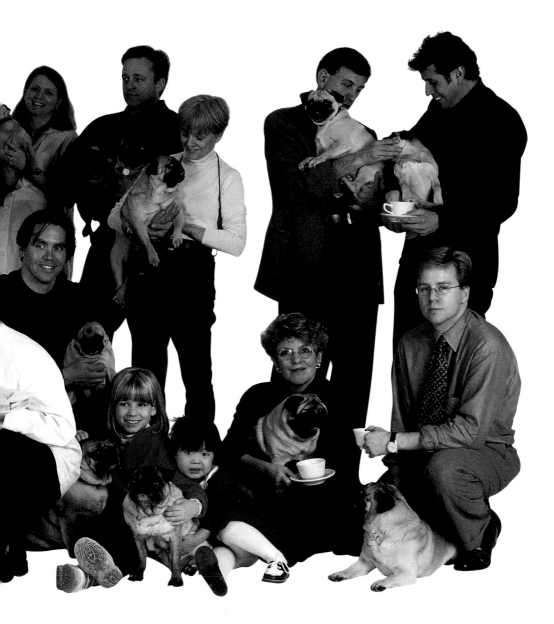

Bottom row, left to right: David Nazaroff and Buddy; Kaete Nazaroff and
Alice; Heather Faulkiner and Ruby; Paul (a true professional); Mark Stettler
and Potomus; Katie Schaubhut with Bijoux; Anni Ming Larson and Annabelle;
Ann Barzola and Fritz; Joshua Findlay and Tuck.

When I first met my wife—the author of

this book—I was told right away that there was already
a great love in her life and that any man who went out
with her would have to accept this fact. On our second
date, I met my rival at Kendall's apartment door, and
stared down at a panting, wheezing, alien-looking crea-
ture—the first pug to whom I had ever been introduced.

With the exception of one beloved, fat, black half-
breed dachshund, my family had always had collies and
Irish setters. I didn't much like small lap dogs, and gaz-
ing down at Kendall's pug, officially named Annabelle,
but known to everyone as "Boogie," I could not imagine
forging a bond with this animal. In fact, I thought her
so ugly, I had a hard time even looking at her. But as the
evening went on, I found myself drawn to those pro-
truding, solicitous eyes.

In the weeks ahead, I had quite a few encounters with
Boogie, and when, about a month after our first meeting,
Kendall had to go out of town on a job, I found myself
volunteering to babysit this pug. She moved into my loft
with her pillow and her food bowl, leash and halter, and
we took our first walk around the block together. It was
quite enjoyable. Boogie's pace was slow, but I soon got

into her rhythm, finding this leisurely tempo a new way to experience New York City street life. As she walked ahead, sometimes pulling on her leash, she reminded me very much of Tina Turner walking downstage in high heels. We returned to the loft, and eventually I went to bed, leaving the dog out in the hall on her pillow.

Sometime later in the night I was awakened to find a face inches from mine—very much like the one pictured here. It was looking, not at me, but at a dimple in the middle of the sheets. What could I do but lift her up and share the bed? Other than snoring like a sailor and shedding like a buffalo, she was a great companion. When Kendall got back a week later, I was seriously attached.

Sometime after that we got married—all three of us.

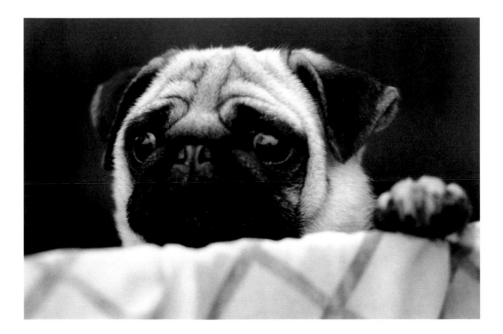

Acknowledgments

Our sincerest thanks to everyone who appeared in the book and to our cover model, Elizora Olivier; IMG Models; Helene Macaulay, hair and make-up; Amy Marth, Moschino Couture for our cover dress; Rich, Brenda, and Becky Goodman; Rose Ganguzza, The Plaza Hotel, New York; Colleen Caslin and Gina Kowl, Asprey & Garrard, New York; the publicity office of the Cathedral of St. John the Divine, New York; Clair Richards; Cecilia Geary; Shirley Thomas; The Pug Dog Club of Greater New York, Inc.; Judi Crowe, Hugapug; Marylou Dymond; Nancy McCorkle; Senga Mortimer; John Jeanopoulis; Kimberly Woods-Slayton and Drive-In Photo Studios, New York; Cakes & Ale Caterers; Paul (a true professional); Monica Willis; Lauren Goodman; and Andrew Southam Studio.

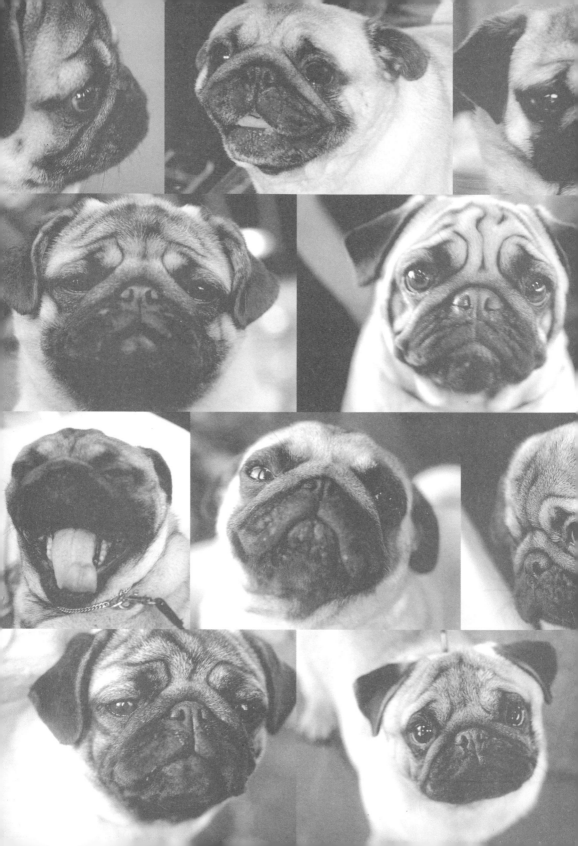